EXPLORING
ANGELICA'S ART

DR. W.F. FERNANDOPULLE

Order this book online at www.trafford.com
or email orders@trafford.com

Most Trafford titles are also available at major online book retailers.

 www.trafford.com

North America & international
toll-free: 844 688 6899 (USA & Canada)
fax: 812 355 4082

Our mission is to efficiently provide the world's finest, most comprehensive book publishing service, enabling every author to experience success. To find out how to publish your book, your way, and have it available worldwide, visit us online at www.trafford.com

Because of the dynamic nature of the Internet, any web addresses or links contained in this book may have changed since publication and may no longer be valid. The views expressed in this work are solely those of the author and do not necessarily reflect the views of the publisher, and the publisher hereby disclaims any responsibility for them.

ISBN: 978-1-6987-0685-6 (sc)
978-1-6987-0684-9 (e)

Library of Congress Control Number: 2021906815

Print information available on the last page.

Trafford rev. 04/01/2021

EXPLORING ANGELICA'S ART

1. Collage

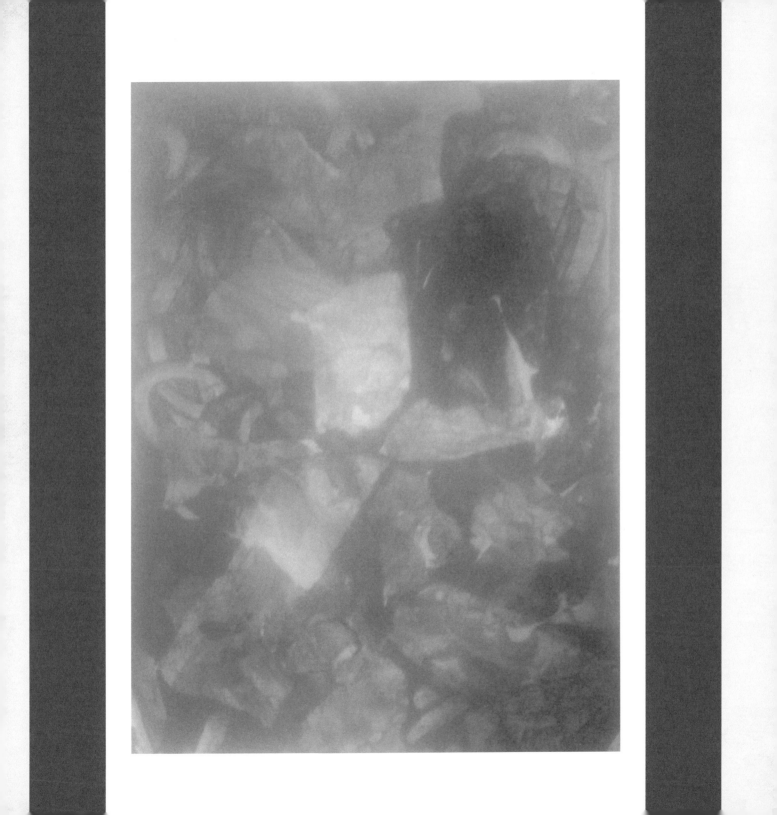

2. The Snake

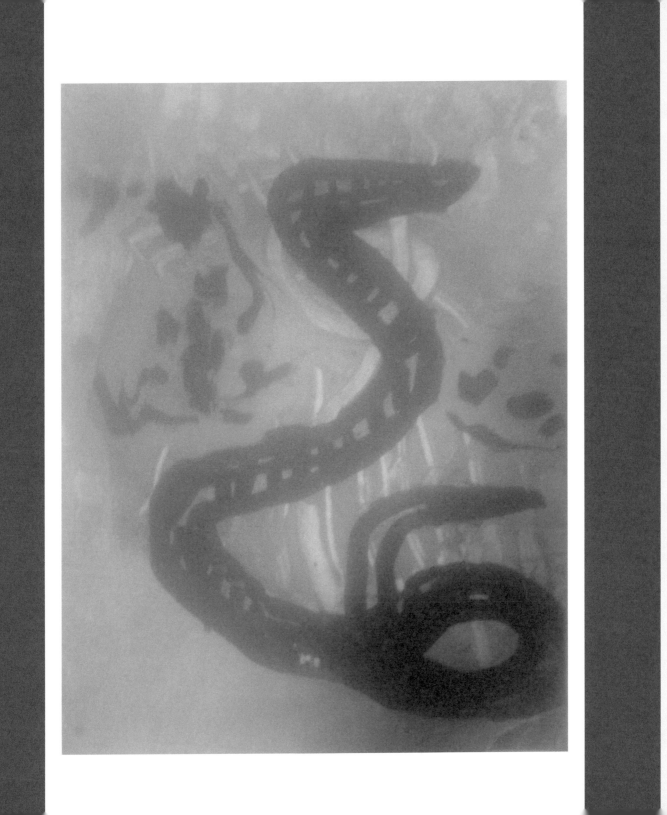

3. The Outside

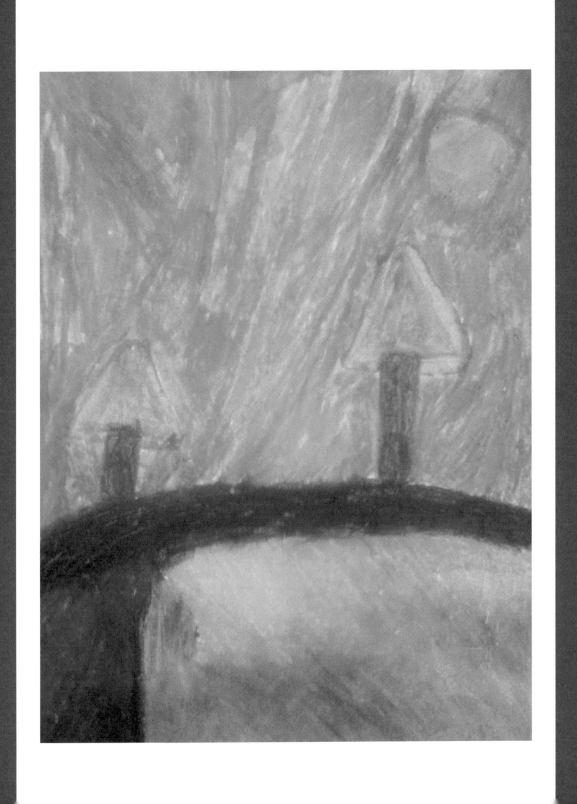

4. Sunny Day

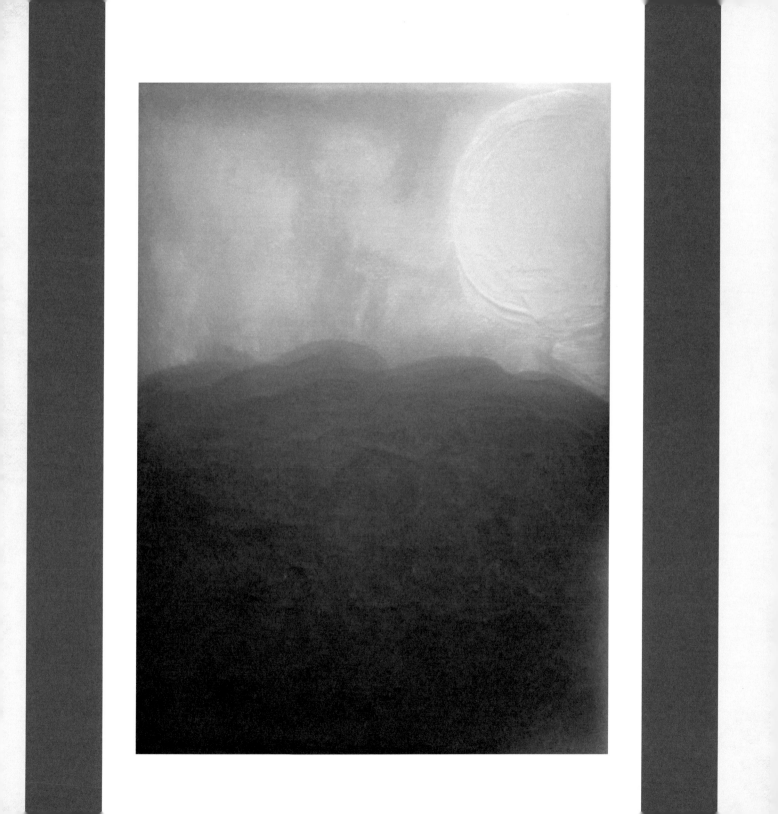

5. Crossing Colors

6. Blue Room

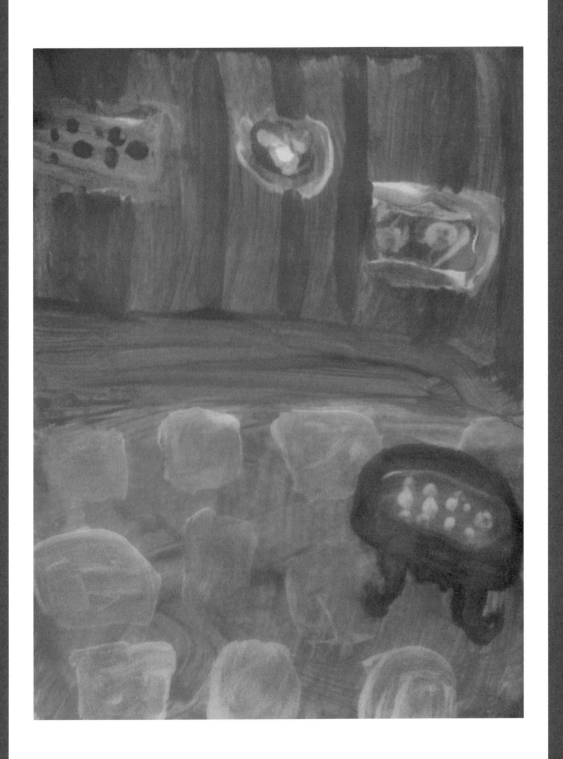

7. Pretty Bird

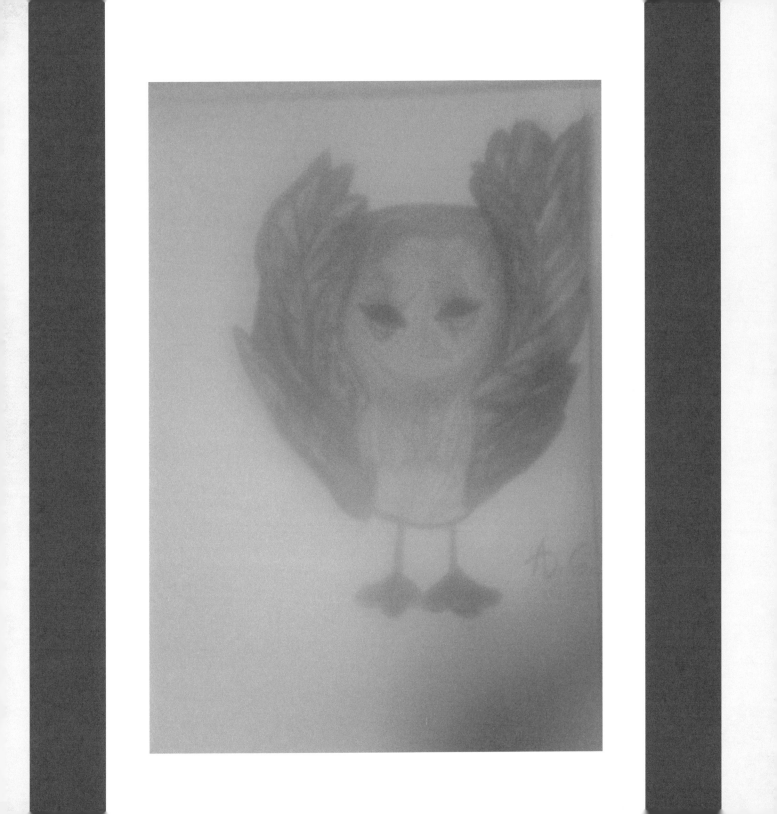

8. New Road

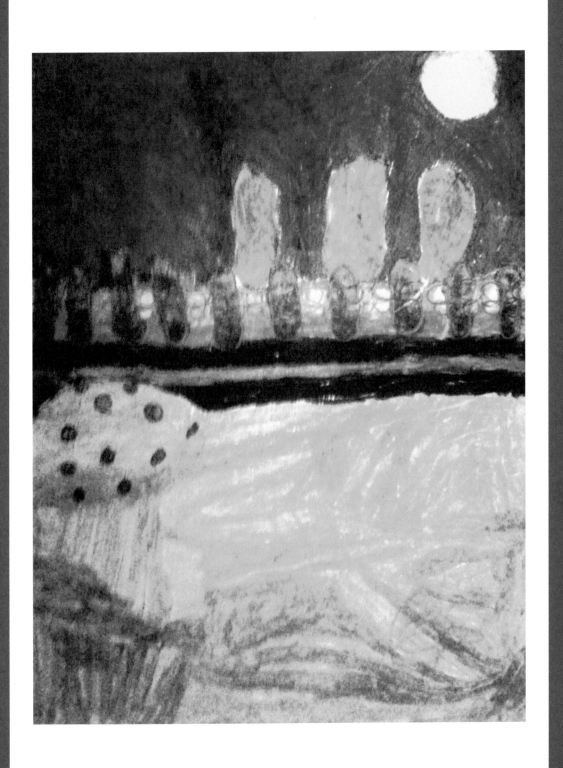

9. My Butterfly

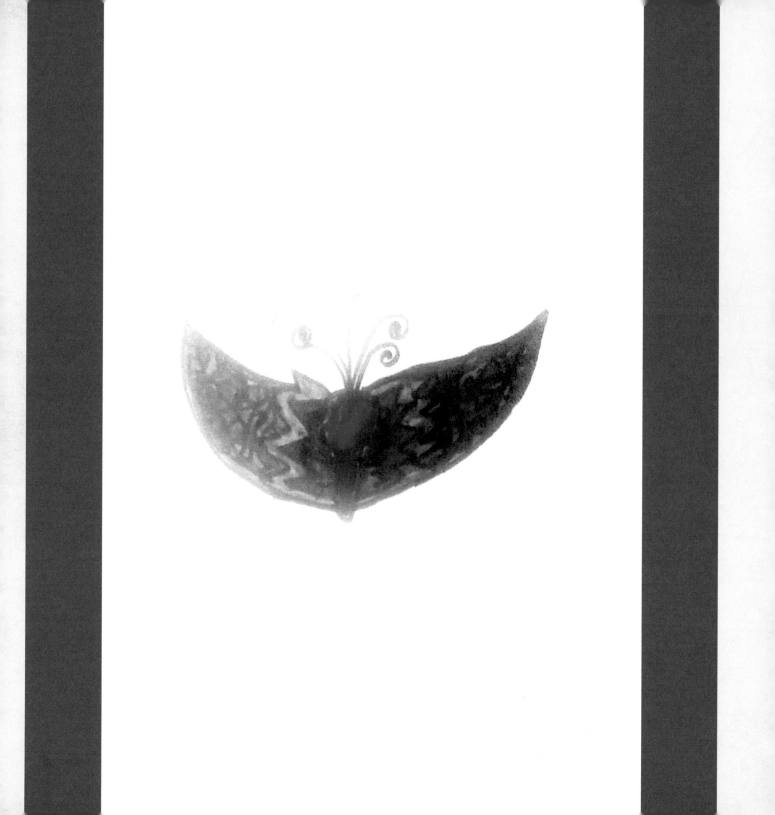

10. Red Skies

11. Lady in Hat

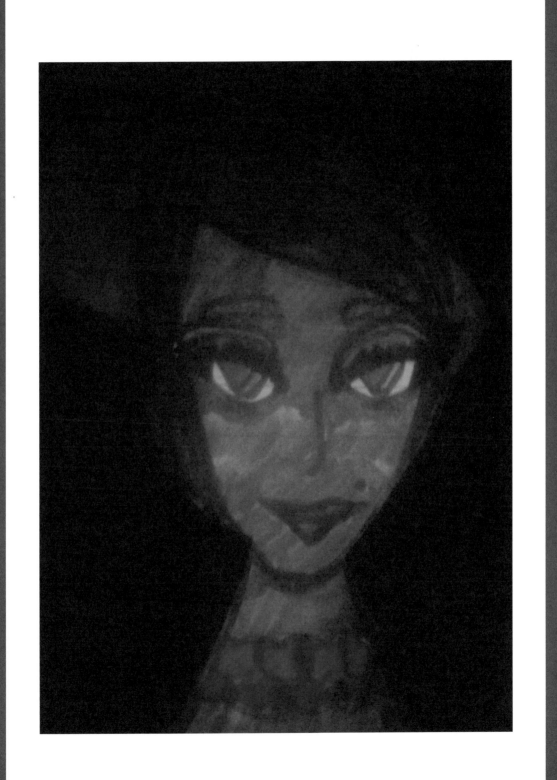

12. Outdoor Play

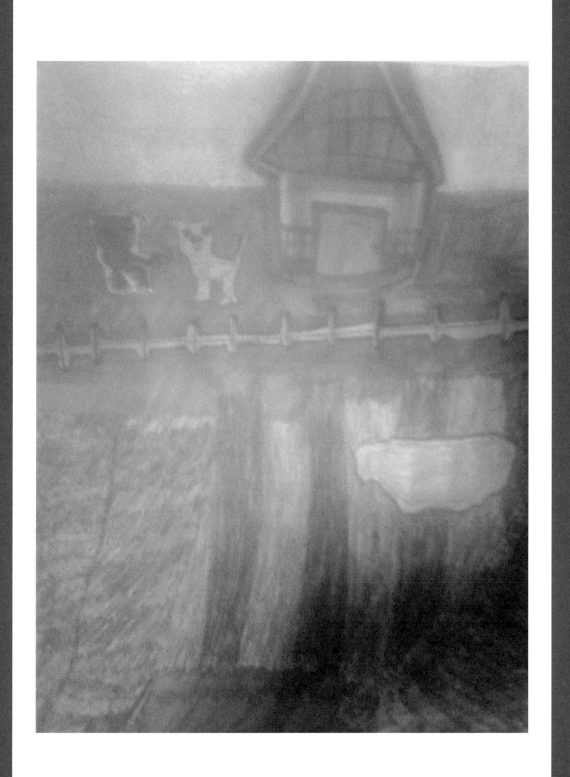

Printed in the United States
by Baker & Taylor Publisher Services